MONO LAKE

TWENTY POSTCARDS

Photography by
DENNIS FLAHERTY

COMPANION PRESS
Santa Barbara, California

© 1995 Companion Press
Santa Barbara, California

All photographs © Dennis Flaherty
Text © 1995 Mark A. Schlenz
All Rights Reserved

Jane Freeburg, Publisher/Editor

Cover Design by Linda Trujillo

Printed and bound in Hong Kong
through Bolton Associates
San Rafael, California

ISBN 0-944197-38-8

Second Printing ✦ 2001

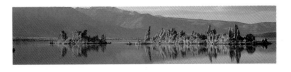

"The birds and animals, trees and grass, rocks, water and wind are our allies. They waken our senses, rouse our passions, renew our spirits and fill us with vision, courage, and joy ... We are Mono Lake."

–*David Gaines, 1987*

*A*t the base of its eastern escarpment, the snow-clad, sky-reaching crest of the Sierra Nevada shimmers reflected across the wide saline surface of a solemn inland sea. Mono Lake survives!

Here, nestled at the juncture of the Great Basin and the Pacific Crest, snow-fed waters coursing from the towering Sierra still find their final rest in a vast, desert-bound, terminal lake. One of the most ancient bodies of water in North America, Mono Lake has collected the melt of ice and snow for aeons. Since the Pleistocene, the landlocked waters of Mono Lake, separated from the Pacific Ocean by the very mountains that feed them, have evaporated into over-arching desert skies, leaving behind the accumulation of salts and minerals that give the lake its briny character. Throughout geologic time, the saline waters of Mono Lake and its surrounding basin have evolved a complex, life-abundant ecosystem in what may, to some, appear to be a void and alkali desert sink. Today, the lake still supports dense populations of brine shrimp and alkali flies which, in turn, feed hundreds of thousands of nesting and breeding migratory water birds. A remnant of the ice ages, an aquatic gem set in an arid landscape formed and carved by prehistoric forces of glaciers, volcanoes, wind, and water, Mono Lake survives!

In historic and more recent times, Mono Lake has endured pressures of human presence as well. Early European and American explorers of the region found indigenous peoples had evolved cultures uniquely adapted to the Lake's resources. The Kuzedika Piute—known to their neighbors as "the fly-

pupae-eaters"—harvested the larvae of Mono's alkali flies and traded salts for other foodstuffs with mountain tribes. With the nineteenth century gold strikes in Aurora and Bodie, prospectors and settlers displaced native lifeways in the Mono Basin. Early in the twentieth century, the basin hosted scattered ranches, farms, and health spas, and the waters of Mono Lake were sought by some for their "therapeutic properties." By 1930 the tide of human population in Southern California had swelled incredibly, and the City of Los Angeles sought the waters of Mono Lake to slake the thirst of its expansion. Fierce court battles and public campaigns have always accompanied the city's diversions of Mono's waters, diversions which jeopardized the integrity of the basin's entire ecosystem. Today, thanks to the ecological vision and tireless efforts of committed volunteers, environmental profession-als, and informed citizens, a 1994 State Water Resources Control Board ruling restricting the city's diversions has established a more environmentally-responsible surface level for the lake. A symbol of our growing recognition of the rights of natural, living things—species, habitats, and ecosystems—Mono Lake survives!

Mono Lake has survived throughout the ages as spectacular testimony to the resiliance, tenacity, and fecundidty of non-human natural forces and processes. Its ongoing survival testifies as well to the growing strength of the human imagination, imagination increasingly capable of appreciating our responsibilities to all members of a planetary household. Mono Lake's continued survival will depend upon our continued commitment to such an ecological imagination. Reflecting the fastness of mountains encircling its shores, reflecting the strength of human spirit embracing its destiny, Mono Lake survives!

Long live Mono Lake 🌿

– Mark A. Schlenz
University of California, Santa Barbara

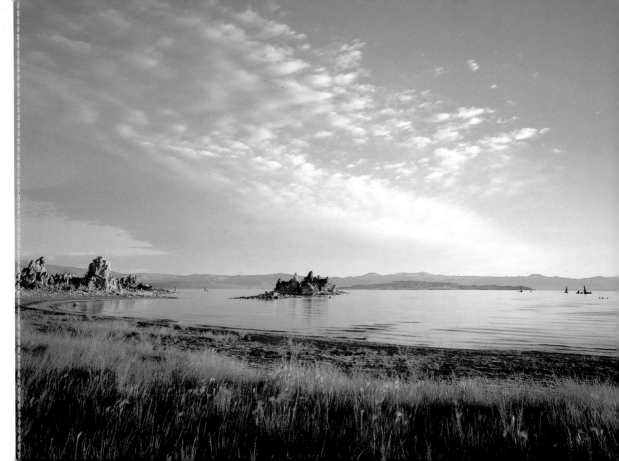

MONO LAKE, CALIFORNIA

Tufa formations along the south shore.

Photograph by Dennis Flaherty

© 1995 Companion Press ● Santa Barbara, California

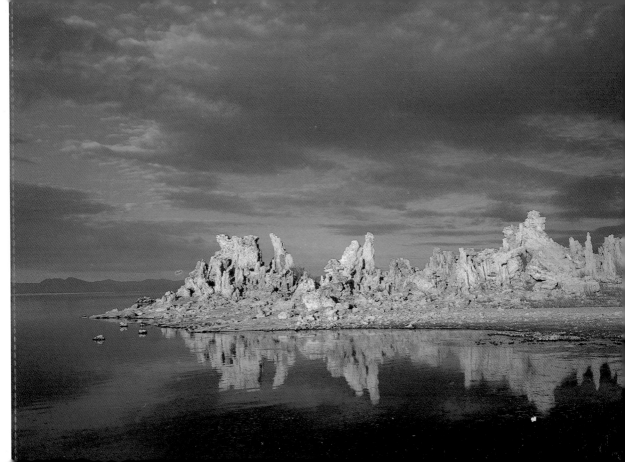

MONO LAKE, CALIFORNIA

Clearing storm at South Tufa Area.

Photograph by Dennis Flaherty

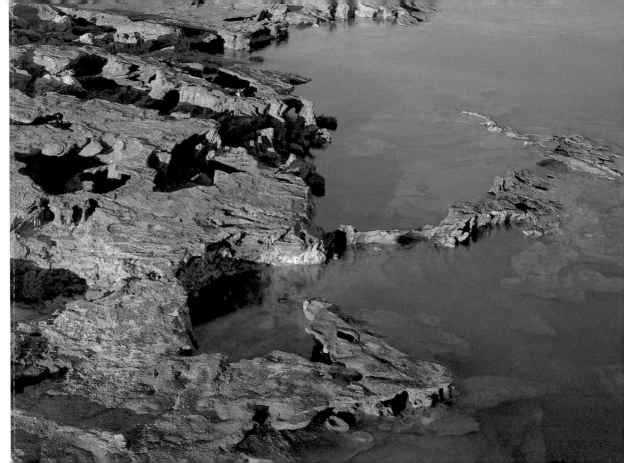

MONO LAKE, CALIFORNIA

Shoreline of an alkaline inland sea.

Photograph by Dennis Flaherty

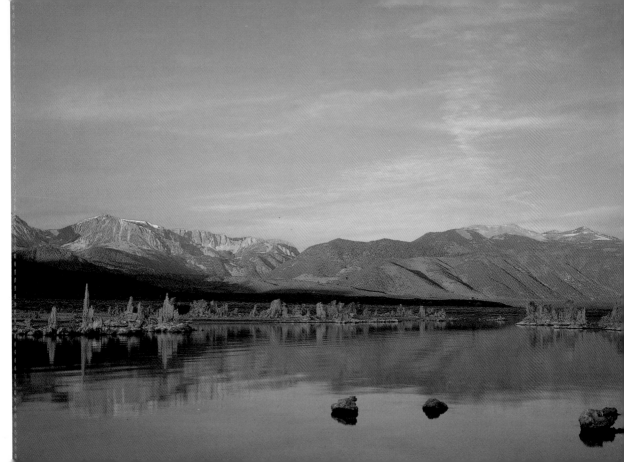

MONO LAKE, CALIFORNIA

First light on the Sierra Nevada.

Photograph by Dennis Flaherty

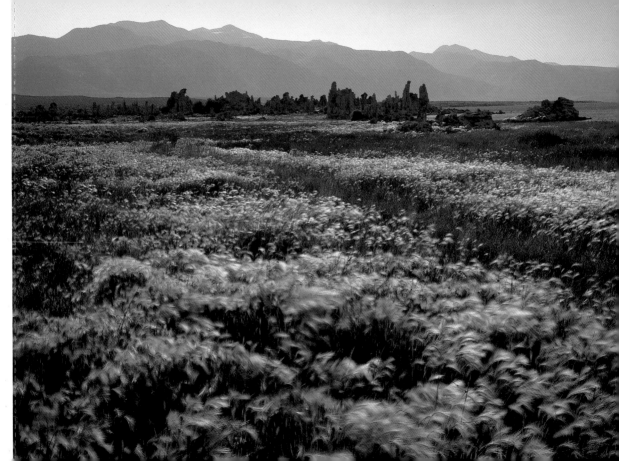

MONO LAKE, CALIFORNIA

Waves of squirrel tail barley near the lake's south shore.

Photograph by Dennis Flaherty

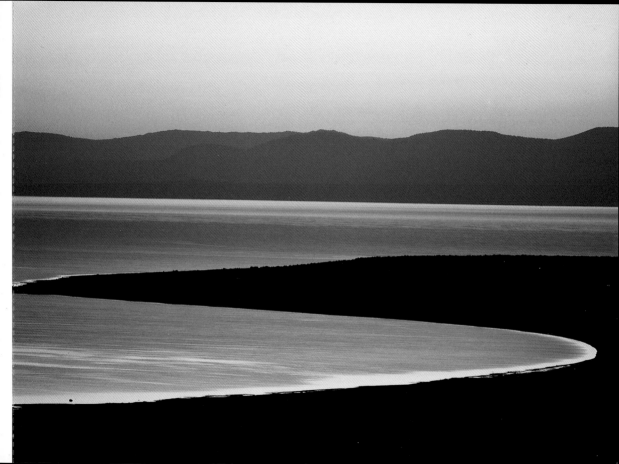

MONO LAKE, CALIFORNIA

Pre-dawn light outlines the lakeshore.

Photograph by Dennis Flaherty

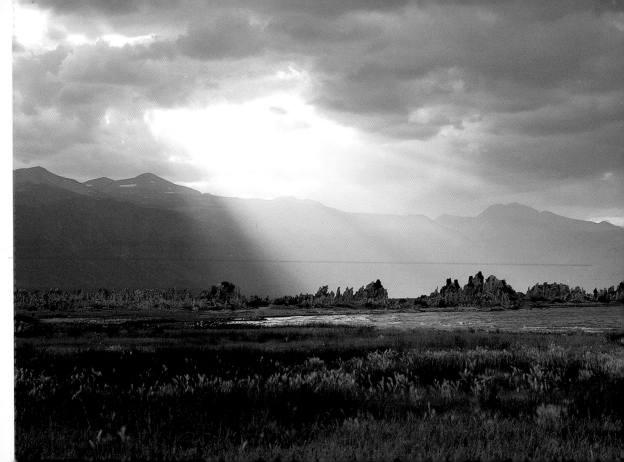

MONO LAKE, CALIFORNIA

Afternoon breezes stir the lake.

Photograph by Dennis Flaherty

© 1995 Companion Press ◗ Santa Barbara, California

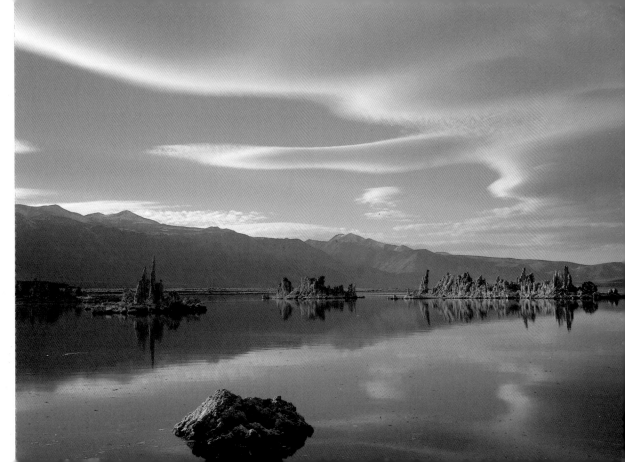

MONO LAKE, CALIFORNIA

A "Sierra wave" cloud formation reflected in Mono Lake.

Photograph by Dennis Flaherty

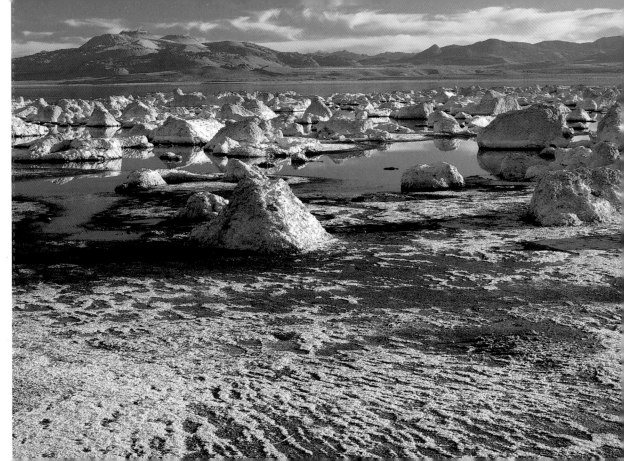

MONO LAKE, CALIFORNIA

Mono Craters from the North Shore.

Photograph by Dennis Flaherty

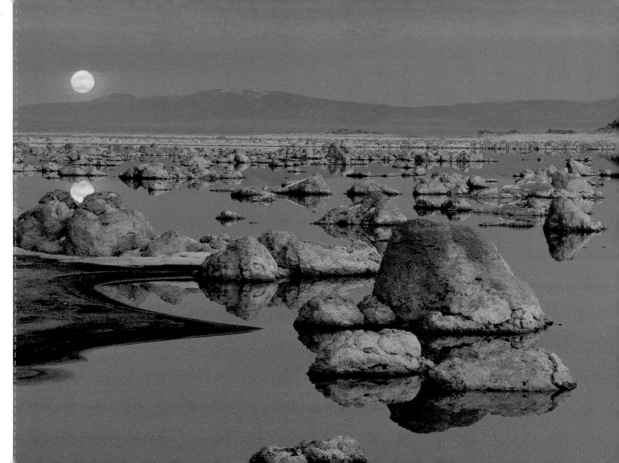

MONO LAKE, CALIFORNIA

Moonrise at Mono Lake.

Photograph by Dennis Flaherty

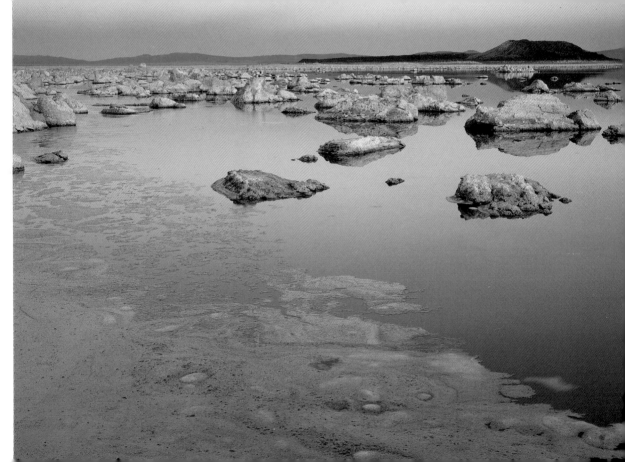

MONO LAKE, CALIFORNIA
Frozen sea foam at twilight.
Photograph by Dennis Flaherty

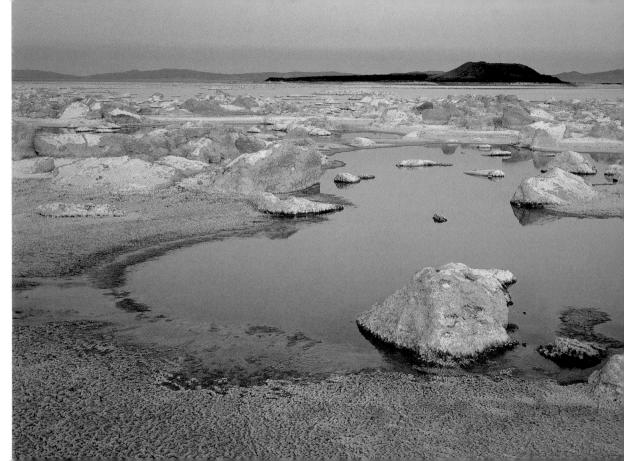

MONO LAKE, CALIFORNIA

Hauntingly beautiful Negit Island.

Photograph by Dennis Flaherty

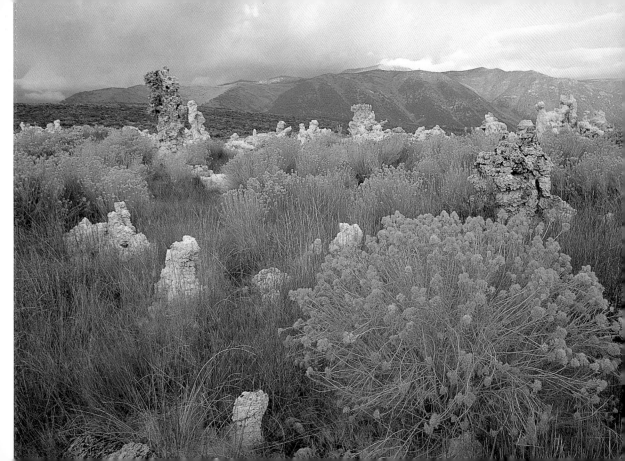

MONO LAKE, CALIFORNIA

Rabbitbrush blooms among tufa.

Photograph by Dennis Flaherty

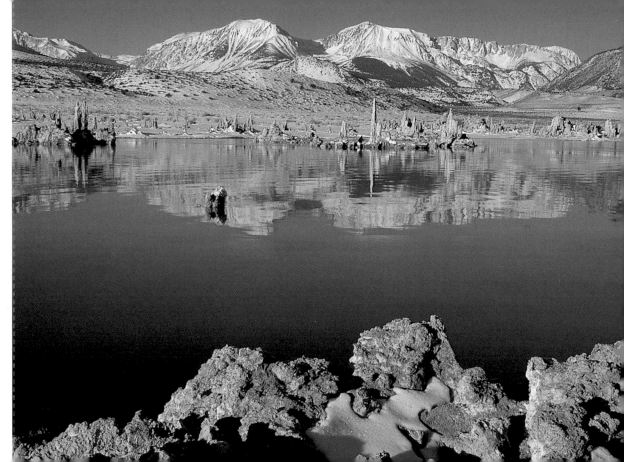

MONO LAKE, CALIFORNIA

Sparkling snow dusts tufa formations.

Photograph by Dennis Flaherty

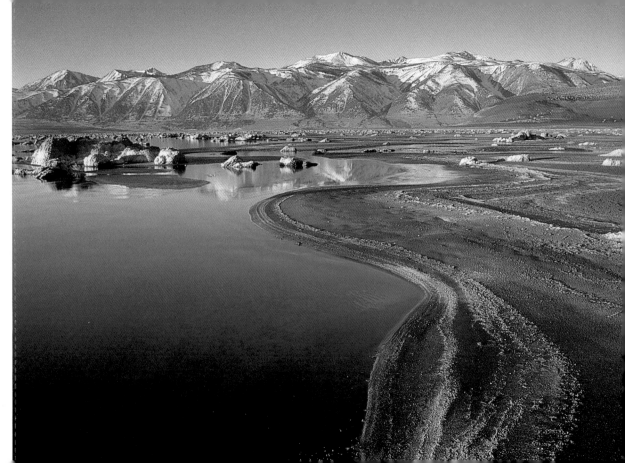

MONO LAKE, CALIFORNIA

Waters sculpt swirling shorelines.

Photograph by Dennis Flaherty

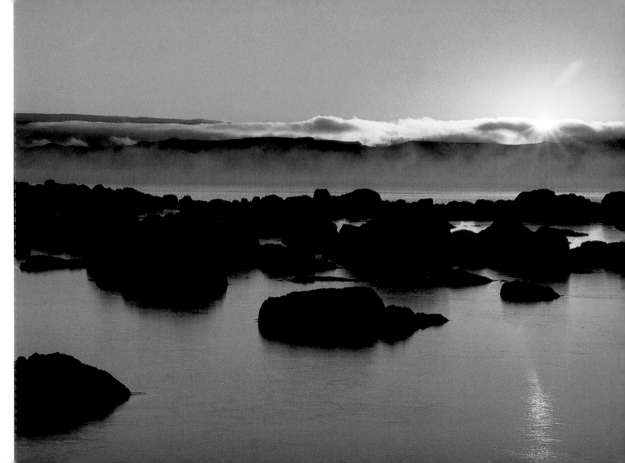

MONO LAKE, CALIFORNIA

Mists gathering at sunset.

Photograph by Dennis Flaherty

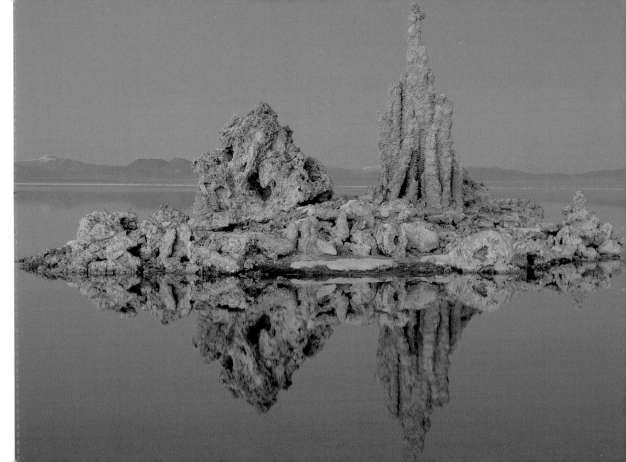

MONO LAKE, CALIFORNIA
Fossilized springs in the frozen dawn.

Photograph by Dennis Flaherty

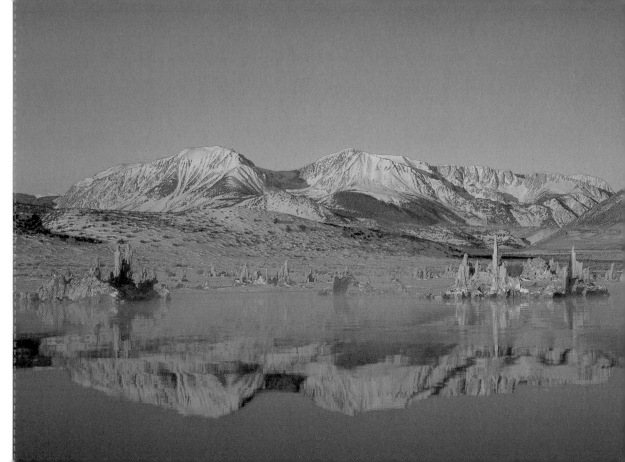

MONO LAKE, CALIFORNIA

Winter reflections.

Photograph by Dennis Flaherty

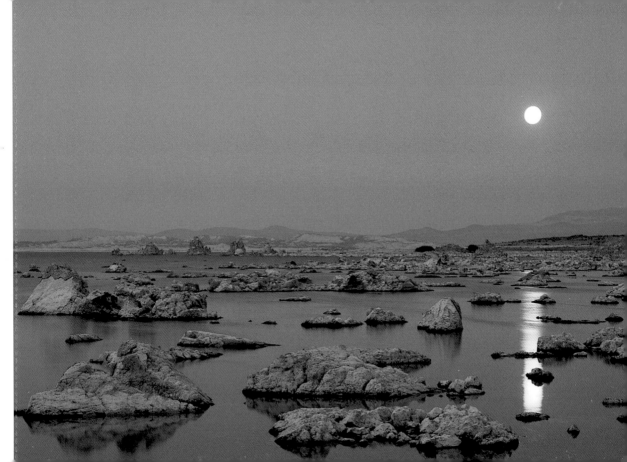

Mono Lake, California

A moonlight path through silent waters.

Photograph by Dennis Flaherty

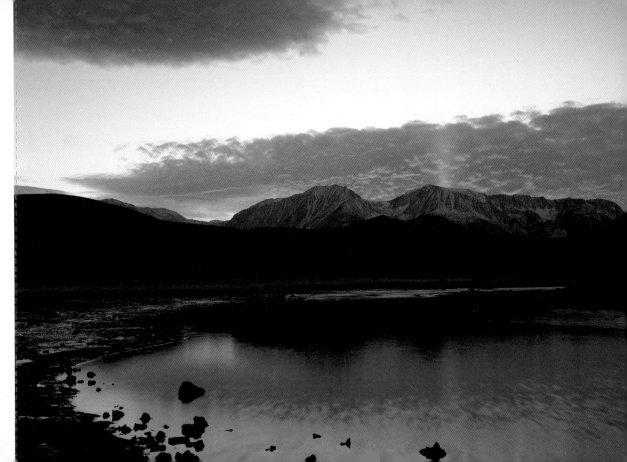

MONO LAKE, CALIFORNIA

Last light in the land of Mono.

Photograph by Dennis Flaherty

© 1995 Companion Press ● Santa Barbara, California